THE GOLFERS

THE STORY BEHIND THE PAINTING

Peter N. Lewis *&* Angela D. Howe

THE GOLFERS
The Story Behind the Painting

National Galleries of Scotland
in association with
The Royal and Ancient Golf Club
of St Andrews

Published by the Trustees of the
National Galleries of Scotland 2004
© The Trustees of the National
Galleries of Scotland

ISBN 1 903278 52 X

Designed by Dalrymple
Typeset in Monotype Fournier
Printed in Belgium by
Snoeck-Ducaju & Zoon

Cover and pages 10 & 11
details from *The Golfers*
by Charles Lees, Scottish National
Portrait Gallery, Edinburgh

1754
250th Anniversary

FOREWORD

Two years ago the Scottish National Portrait Gallery bought one of the greatest icons of the game of golf, Charles Lees' masterpiece, *The Golfers*. The Gallery was able to acquire the painting through the generosity of, amongst others, the Heritage Lottery Fund, The Art Fund, the Cheape Family Trust and The Royal and Ancient Golf Club of St Andrews. *The Golfers*, completed in 1847, shows a two ball foursome being played on the Old Course at St Andrews. It is appropriate that Peter Lewis, Golf Heritage Secretary of The Royal and Ancient Golf Club and Director of the British Golf Museum, and Angela Howe, Curator of the Golf Heritage Department, have written this book, which places the painting in its social and sporting context. *The Golfers* is now publicly owned and this book, which has been supported by The Royal and Ancient Golf Club, will help to make it known to a far wider audience than the artist or the Victorian golfers themselves could ever have imagined.

SIR TIMOTHY CLIFFORD
Director-General · National Galleries of Scotland

JAMES HOLLOWAY
Director · Scottish National Portrait Gallery

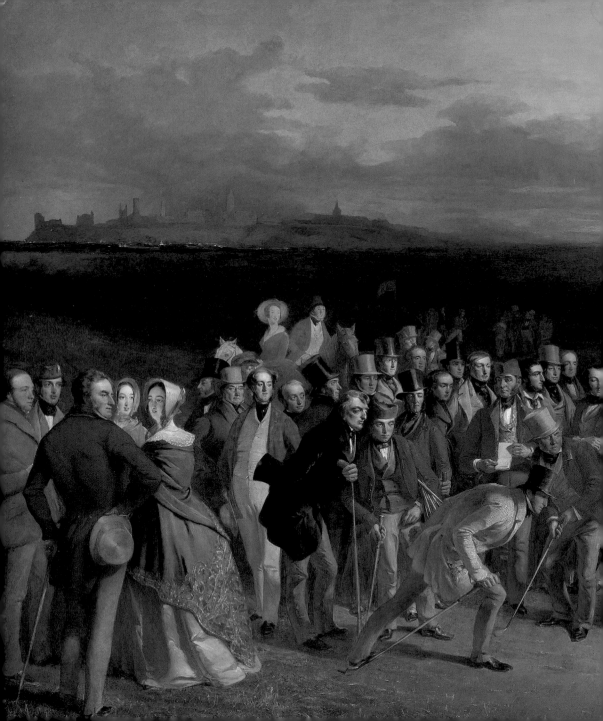

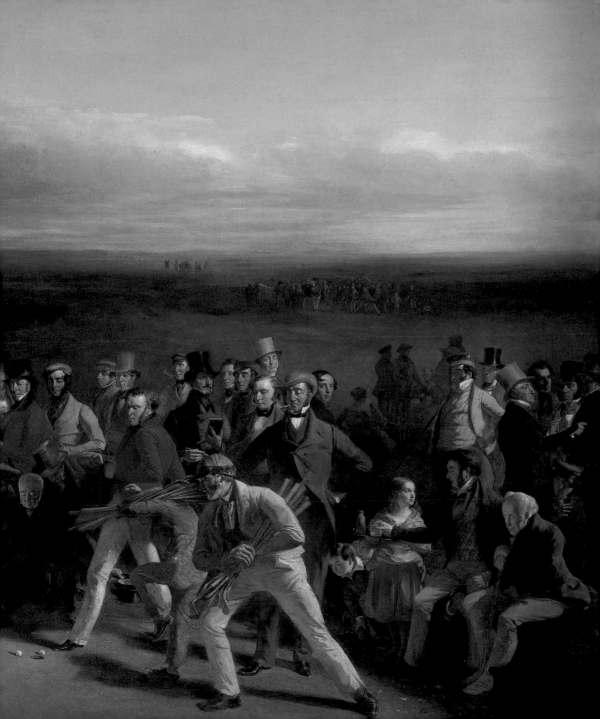

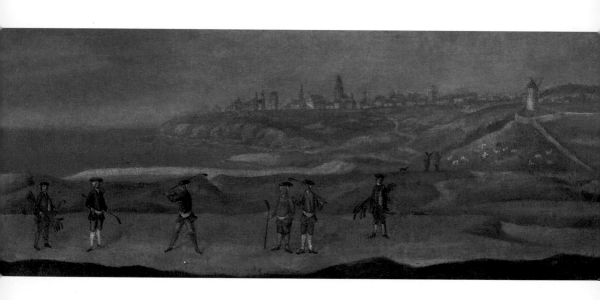

[1] Unknown artist, *Golf at St Andrews*, about 1740

Collection of The Royal and Ancient Golf Club of St Andrews

THE GOLFERS

The earliest known painting of a golfing scene at St Andrews dates from around 1740 and is in the collection of The Royal and Ancient Golf Club [1]. It depicts four golfers and two caddies in the foreground, while in the background there are two shepherds, their dog, and a flock of sheep contentedly grazing on the links. The windmill, which can be seen on the right-hand side of the painting, was demolished in the 1760s. The painting captures a match in progress. One of two players, who wear blue-green jackets, is about to hit his shot while his partner and caddie watch. Their opponents, wearing predominantly red jackets, stand off to one side, following the action with interest. The names of the players and the artist are not known.

Remarkably, there were very few images produced of golf being played at St Andrews and it is not until the early 1840s that G. Cook made a series of sketches of golf matches at St Andrews, featuring many of the leading members of the R&A [2]. One of these, in the collection of The Royal and Ancient Golf Club, dated 1843, shows a match being played. Dr Patrick Moodie is about to hit his shot. To the left stand Hugh Lyon Playfair and his brother, the portly Colonel William Playfair. John Campbell of Glensaddell sits on the ground on the far left of the sketch, quietly smoking while watching. Moodie is observed on the right by Samuel Messieux and Robert Christie. Between Moodie and Messieux, another two players watch a match at the previous hole.

Two known sketches by Cook are in the East Lothian Museum Service collection, one of which was used as the basis for the decoration on a small cigar box in the R&A collection and another, which is titled *The First Hole*. Many of the same players, who are depicted in these two drawings, are in the 1843 sketch.

Significantly, Hugh Lyon Playfair and John Campbell take centre stage in a magnificent panoramic golfing painting, which was completed in 1847. This was *The Golfers: A Grand Match Played over the Links of St Andrews on the Day of the Annual Meeting of the Royal and Ancient Golf Club*, and the artist was Charles Lees. What follows is the story of the artist and the story of that painting.

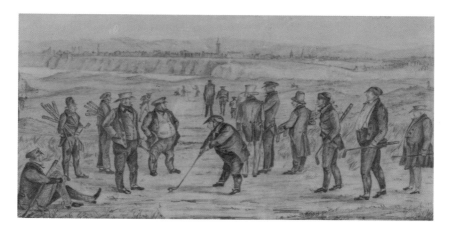

[2] G. Cook, *Golfing at St Andrews*, 1843

Collection of The Royal and Ancient Golf Club of St Andrews

Charles Lees was a leading Scottish artist during one of the most interesting periods in British art. Born in Cupar, Fife, in 1800, he studied art in Edinburgh and was taught by the portraitist Sir Henry Raeburn. After spending time in Rome, a long-established learning ground for developing artists, Lees returned to Scotland, setting himself up as a portrait painter in Edinburgh. He showed works at the Royal Scottish Academy annual exhibitions every year between 1822 and 1880, with the exception of the years 1823 and 1826. In 1829 he was elected a full member of the Academy. For the twelve years prior to his death, Lees acted as treasurer of this prestigious institution. In his obituary published in the Academy's *Annual Report* for 1880, it was noted to the artist's credit that this was a position which 'by his sagacity and business habits, he was so well qualified to fill'.

Earning his living by his brush, Lees' output reflected the then current tastes of the art-buying public. He exhibited more than 200 paintings at the Royal Scottish Academy, which displayed a wide range of skills. These consisted of ninety portraits, forty-seven small scale domestic scenes, thirty-one landscapes and seascapes, eleven architectural scenes, nine historical paintings and three biblical paintings. In addition to these, he also exhibited eighteen sporting subjects. Many of his themes derived from Scottish history, Scottish contemporary life and national pastimes.

By 1847, the year in which Lees finished *The Golfers*, there was great diversity in the British art scene. Among the British artists who were already well established were J. M. W. Turner, Sir Edwin Landseer and Sir Francis Grant, while the Pre-Raphaelite Brotherhood was formed in 1848. One of Lees' contemporaries was the highly respected painter Sir Francis Grant, who came from Kilgraston in Perthshire. Like Lees, Grant was noted for his

skills in portraiture and where Lees channelled his energies into the affairs of Scottish art and the Royal Scottish Academy, Grant settled in London and became president of the Royal Academy in 1865. He had long-established himself as one of the leading society portrait painters of his generation as well as executing many sporting portraits. Lees and Grant, therefore, had much in common [3].

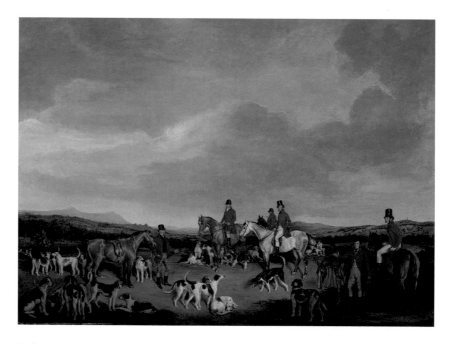

[3] Francis Grant, *A Meet of the Fife Hounds*, 1833

On loan from the Kintore Trust to the Scottish National Portrait Gallery, Edinburgh

This painting contrasts Grant's early style with that of Lees and depicts John Whyte Melville and John Grant, both of whom appear in *The Golfers*.

The annual exhibitions at the Academies and other exhibiting venues provided an ideal meeting place for artists and potential buyers. Where, previously, paintings had often been commissioned by members of the aristocracy, the growing wealth of Britain as an industrial nation led to a new democracy in art, with entrepreneurs, merchants and manufacturers taking their place in the art market. It is probably safe to assume that Lees showed his newest works each year, so that the year of exhibition is likely to be very close to the year in which the painting was completed.

Contemporary subject matter had become increasingly popular, which perhaps explains why Lees turned from portraiture to sporting subjects in the 1840s. It is of particular interest that the first major sporting work that Lees produced was *The Golfers*. The game of golf was still predominantly Scottish, and of the twenty-three active British golf clubs in existence by the end of the 1840s, all but two of these were in Scotland. Golf was, however, also being played throughout the British Empire by Scots in the military, the civil service or in commerce, as people tend to take their games with them when they are living abroad in an expatriate community. It must have been the Scottish nature of the game, which appealed to Lees. Indeed, his subsequent sporting paintings concentrated on Scottish sports and pastimes. Among these were *Skaters on Duddingston Loch* (exhibited 1854), *The Grand Curling Match at Linlithgow* (1861), *Shinty – Scene on the Ice at Duddingston* (1861), *Hockey on the Ice on St Margaret's Loch* (1864) and *Curling on Duddingston Loch* (1867). His other golf pictures included: *At Bruntsfield Links* (1855), *Summer Evening on Musselburgh Links* (1860) and *Golfers Going Out on Leven Links* (1864).

Lees' skill as both a portrait painter and a landscape artist is evident in these sporting works. Within each chosen theme he seeks to illustrate a highly dramatic central story, usually characterised by the illusion of

movement and the dramatic postures of the main characters. Often he includes eye-catching touches in the margins of the pictures, such as the ginger beer girl in *The Golfers*, the orange seller in *The Grand Curling Match at Linlithgow* [4] or the picnic basket in *Curling on Duddingston Loch* [5]. Whereas in *The Golfers*, the central story is literally in the centre of the picture, in *The Grand Curling Match at Linlithgow* and *Curling on Duddingston Loch*, the main drama takes place at the left-hand side of the canvas.

According to contemporary newspaper reports, Lees was paid £400 for *The Golfers*. This was a substantial sum of money in 1847, equivalent to over £20,000 in today's values and compares favourably with what other leading artists of the time were able to command. For example, in 1849, the Pre-Raphaelite painter John Everett Millais sold his painting, *Isabella* for £150. By 1852, when the Brotherhood had come to greater prominence, he sold the well-known picture, *Ophelia* for £315. By 1860, Millais was selling works for up to £1,000.

OPPOSITE ABOVE

[4] Charles Lees, *The Grand Curling Match at Linlithgow*, 1861
Collection of the Royal Caledonian Curling Club

OPPOSITE BELOW

[5] Charles Lees, *Curling on Duddingston Loch*, 1867
Collection of the Royal Caledonian Curling Club

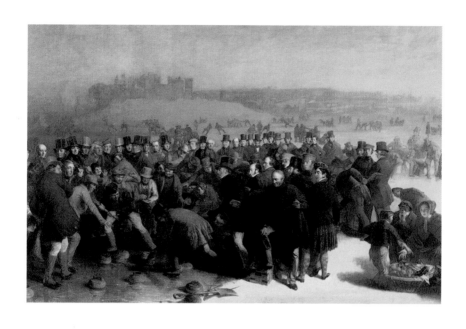

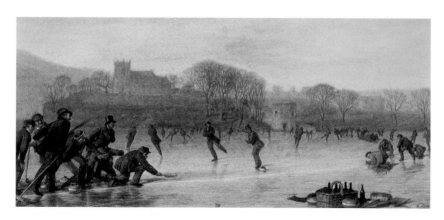

The Golfers was bought by the print seller Alexander Hill [6] and there is a strong possibility that the painting was actually commissioned by him. Based at his gallery, 67 Princes Street, Edinburgh, Hill was a key figure in the Edinburgh art world. He had been appointed 'Colourman, Printseller and Stationer' to the Society of Artists in Edinburgh in 1830 and he also became official 'Publisher and Printseller' to Queen Victoria and Prince Albert. He published works by some of the finest and most distinguished

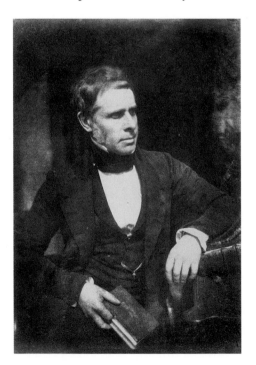

LEFT

[6] *Alexander Hill*, publisher and print seller, photographed by his brother, D. O. Hill, and Robert Adamson, 1844-5

Scottish National Photography Collection, Scottish National Portrait Gallery, Edinburgh

OPPOSITE

[7] Title page of *Golfiana* published by William Blackwood and Alexander Hill in 1842

Collection of The Royal and Ancient Golf Club of St Andrews

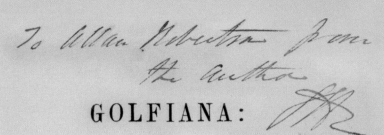

To Allan Robertson from the author

GOLFIANA:

OR,

NICETIES CONNECTED WITH THE

GAME OF GOLF.

DEDICATED, WITH RESPECT,

TO THE

MEMBERS OF ALL GOLFING CLUBS,

AND TO THOSE OF

St Andrews & North Berwick

IN PARTICULAR.

BY GEORGE FULLERTON CARNEGIE.

EDINBURGH:

WILLIAM BLACKWOOD & SONS, GEORGE STREET; AND
ALEXANDER HILL, PRINCES' STREET.

1842.

Price 5s.

artists in the country, as well as works by artists who are now little known. Hill had an appreciation of art that made him intuitive to the kind of works that would sell. He also commissioned works of art and was an influential force through the interest he bestowed upon contemporary artists, effectively promoting their careers and artistic reputation.

Hill's first major success, as he launched his publishing career, was with the print of *The Entrance of Prince Charles Edward into Edinburgh, towards Holyrood, after Defeating Sir John Cope at Prestonpans* by Thomas Duncan, which he commissioned around 1838. The paintings that Hill had engraved tell us which artists were popular and indicate the wide-ranging subject matter available to an ever-expanding art market. Among his published works were three large engravings by his younger brother, the artist, David Octavius Hill. The subjects were Windsor Castle, old and new Edinburgh and the Braes of Ballochmyle. Other Scottish artists whose works Hill engraved and published, included Sir William Allan, William Bonnar, Sir George Harvey, Charles Lees, John M. Barclay and Sir Joseph Noel Paton, who was a particular favourite. Hill's obituary in *The Evening Courant* (18 June 1866) refers to nine works by Paton that Hill had published.

The link between Alexander Hill and *The Golfers* reveals some intriguing golfing and cultural connections. Hill, who ultimately became a member of the Edinburgh Burgess Golf Society in 1848, had originally begun his career in publishing and worked for the publisher, William Blackwood until 1826. In 1833, he reverted to his role as a publisher and, in partnership with William Blackwood, produced a small, sixteen-page book of three poems by George Fullerton Carnegie entitled *Golfiana or Niceties Connected with the Game of Golf* [7]. One of the poems, running to 138 lines, was called *The First Hole at St Andrews on a Crowded Day,* which featured verbal sketches of twenty-five eminent golfers.

Nine years later, in 1842, Hill and Blackwood published another edition of Carnegie's *Golfiana*, which contained a fourth poem, *Another Peep at the Links*, which was the sequel to *The First Hole*. The importance of the 1842 edition cannot be underestimated, and especially the two poems *The First Hole at St Andrews on a Crowded Day* and *Another Peep at the Links* as they give a rare and humorous insight into the foibles of the leading players of the day at St Andrews. It is interesting that of the fifty-three characters depicted by Charles Lees in *The Golfers*, twenty were described in the two poems written by Carnegie. It is possible that the poems may have helped Lees in the gestation of the painting in terms of the characters he might include.

Another intriguing link is with Alexander Hill's younger brother, David Octavius Hill, the pioneer photographer, who began his career as a genre and landscape artist and who was appointed secretary of the Royal Scottish Academy in 1830 [8]. He was a prolific artist who exhibited 128 works at the Royal Scottish Academy between 1821 and 1842. Between the years 1843 and 1848, however, he exhibited only seventeen paintings. Significantly, this was the five-year period in which he was heavily involved in his photographic work. In 1843, Hill began work on a massive depiction of the split of the Free Church of Scotland from the Church of Scotland and the resultant first General Assembly of the Free Church. This was a huge work, which Hill did not complete until 1866. Measuring nearly twelve feet wide by five feet high, it contains over 450 portraits of the leading lay and clerical figures who took part in that event. Its final title was *The Signing of the Deed of Demission* [9]. Hill became interested in the new art of photography and saw it as a tool to record portrait likenesses for his great painting, an idea suggested to him by David Brewster, the principal of United College, St Andrews, and a friend of William Henry Fox Talbot. It was Talbot who

had discovered the calotype process, which made photographing people a practical proposition. Brewster, together with his neighbour, Hugh Lyon Playfair and a local medical practitioner, Dr John Adamson, had all been carrying out experiments in St Andrews with the new medium of photography. Brewster suggested that Hill contact John Adamson's younger brother, Robert. Although apparently originally sceptical, Hill was quickly converted to the potential of this new medium as an aid to his painting. The result was the formation of a partnership between Hill and the trained engineer turned photographer, Robert Adamson. It was this partnership that was to pioneer photography in Scotland and to raise it to an art form.

LEFT

[8] *David Octavius Hill* photographed by D.O. Hill and Robert Adamson, 1844–5

Scottish National Photography Collection, Scottish National Portrait Gallery, Edinburgh

OPPOSITE

[9] David Octavius Hill, *The Signing of the Deed of Demission*, detail showing D. O. Hill and Robert Adamson with his camera

Collection of the Free Church of Scotland

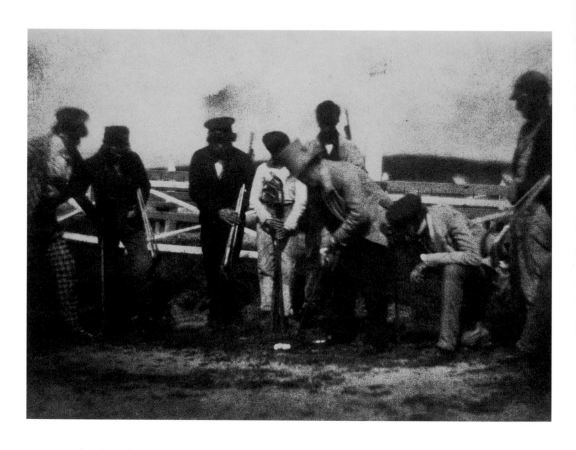

[10] Earliest known photograph of golf at St Andrews, about 1845
by D.O. Hill and Robert Adamson

The photograph shows from left to right: Captain David Campbell, Allan Robertson,
Tom Morris, an unidentified caddie, possibly Bob Andrew, an unidentified person, Hugh Lyon
Playfair, Willie Dunn and Watty Alexander.

Scottish National Photography Collection, Scottish National Portrait Gallery, Edinburgh

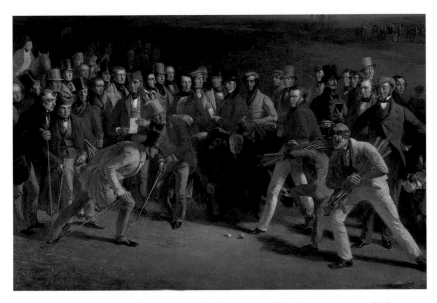

[11] The centre section from *The Golfers* shows virtually the same group of players as appear in the Hill and Adamson photograph opposite.

The earliest known photograph of golf was taken in St Andrews around 1845, probably by Hill and Adamson [10]. The subjects are posed to act out the drama of a golfing match 'in progress', with the spectators and caddies watching in anticipation of Hugh Lyon Playfair's next putt. The significance of the photograph becomes even greater when it is studied in conjunction with *The Golfers*. The photograph bears a striking resemblance to the central section of Lees' painting [11], but with the similar poses of some of the figures in the photograph transposed from right to left in the painting. This similarity becomes even more significant when one considers the close

relationship that existed between Lees and the two Hill brothers. David Octavius Hill and Charles Lees were both leading members of the Royal Scottish Academy. As a regular, Edinburgh-based contributor to the annual show, Lees would presumably have come into close contact with Hill who was the secretary.

The correlation between the photograph and *The Golfers* would suggest that Lees might even have commissioned the photograph to use in the composition of the painting. The calotypes taken by Hill and Adamson for *The Signing of the Deed of Demission* have been described as 'sketches', to distinguish them from their calotype portraiture. They were not intended to be finished portraits, but rather as an aid to Hill's painting. The fact that the photograph of the group of golfers is blurred and lacks the usual clarity of Hill and Adamson's work lends credence to the idea that it was intended as a sketch, with the emphasis on composition and movement rather than the capturing of individual facial features. Lees exhibited oil sketches, or studies, of nine of the figures that appear in *The Golfers* at the Royal Scottish Academy in 1846, a year before the completion of the painting. The closeness of the dating and the strong personal connections between Lees and the two Hill brothers means that the similarity between the painting and the photograph cannot be a coincidence. The fact that Lees was at work on *The Golfers* by 1846, and possibly in 1845, supports a date of 1845 for the photograph.

The speculative conclusion in trying to tie these three different strands of poetry, photography, and painting together, seems to suggest that there is a strong possibility that the two poems by George Fullerton Carnegie, mentioned above, provided the inspiration for *The Golfers*. It is equally likely that the photograph by Hill and Adamson played a part in the creation of the painting.

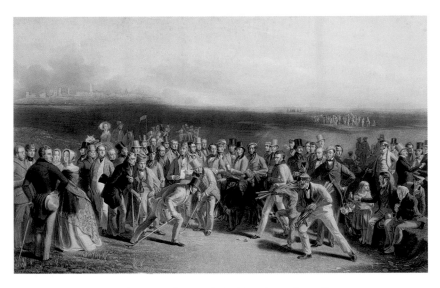

[12] The 1850 print of *The Golfers*, published by Alexander Hill
Scottish National Portrait Gallery, Edinburgh

 Alexander Hill's primary interest in the painting after its completion was, of course, to sell engravings of it. The engraving for the original 1850 print was made by Charles E. Wagstaffe [12]. Indeed, it must have been one of Wagstaffe's last works, for he died in the same year. Wagstaffe, who was born in 1808, was a portrait and figure engraver, who worked mainly in London. He appears to have worked predominantly for print publishers, especially in the 1840s. His works were issued in large numbers and proved very popular. He engraved works after some of the most prestigious artists of the day, including Sir Edwin Landseer, Daniel Maclise and William Frith. From 1840 to 1842 he was president of the Artist's Annuity Fund and

in 1846 he served as secretary of the Institute of Fine Arts. The date of declaration of the engraving in the Print Sellers' Register was 1 October 1850. The register records that there were fifty artist's proofs, each being sold at ten guineas, twenty presentation copies with no price indicated, one hundred proofs at six guineas, and an unspecified number of ordinary prints, each selling for three guineas.

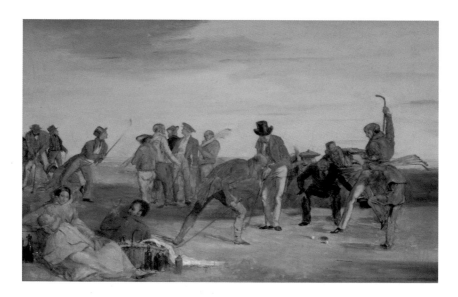

[13] Charles Lees, oil sketch for *The Golfers*
Collection of The Royal and Ancient Golf Club of St Andrews

There are over fifty figures in the completed painting of *The Golfers*, but it is highly unlikely that all of these people were actually present at the match. Two small, undated oils by Lees exist, which were almost certainly the preliminary sketches for the painting. One is in the R&A's collection and the other is in the Scottish National Portrait Gallery [13 & 14]. The R&A's

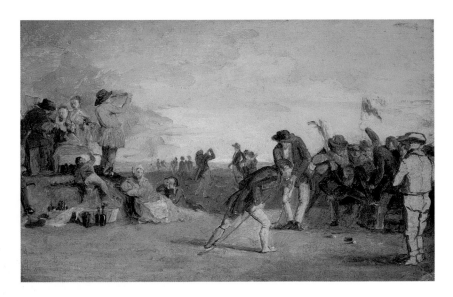

[14] Charles Lees, oil sketch for *The Golfers*
Scottish National Portrait Gallery, Edinburgh

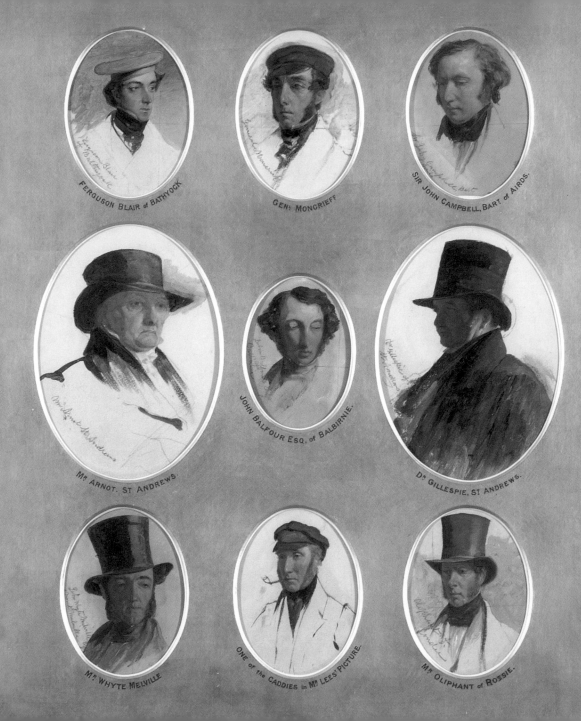

FERGUSON BLAIR of BATHYOCK.

GENL MONCRIEFF.

SIR JOHN CAMPBELL, BART of AIRDS.

MR ARNOT. ST ANDREWS.

JOHN BALFOUR ESQ of BALBIRNIE.

DR GILLESPIE. ST ANDREWS.

MR WHYTE MELVILLE.

ONE OF THE CADDIES IN MR LEES PICTURE.

MR OLIPHANT of ROSSIE.

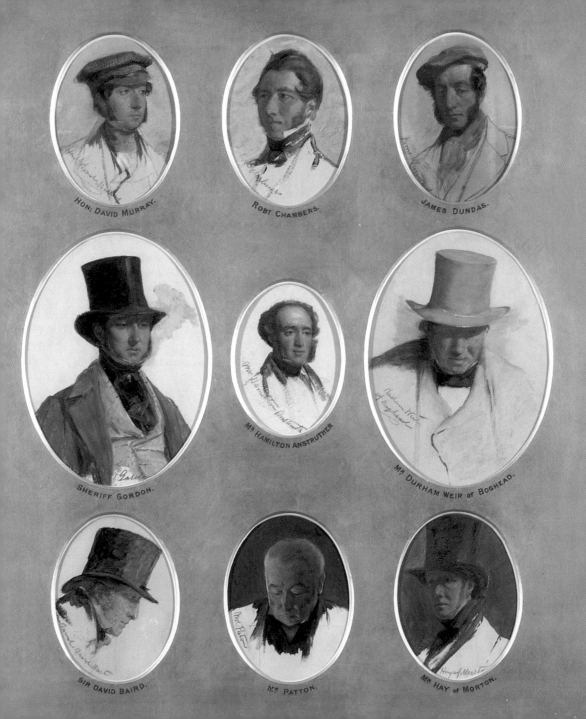

HON: DAVID MURRAY.

ROBT CHAMBERS.

JAMES DUNDAS.

SHERIFF GORDON.

MR HAMILTON ANSTRUTHER

MR DURHAM WEIR of BOGHEAD.

SIR DAVID BAIRD.

MR PATTON.

MR HAY of MORTON.

sketch shows the climax of the contest for the hole, but with far fewer people present – in fact, seventeen in number, including eight golfers playing in another match. Indeed, the only spectators watching the principal match are a husband, wife and baby who are also enjoying a picnic. This is probably what a typical match scene in the 1840s would have looked like. The Scottish National Portrait Gallery sketch is rather different. There are more figures than in the R&A sketch, but the central drama of the golfers putting is more to the right of the drawing and there is a much more elaborate picnic scene dominating the left hand side of the work.

Having created a basic scene, Lees proceeded to make drawings of the people to be featured in the large painting, using a similar working method to the one he would use for *The Grand Curling Match at Linlithgow*. Fifteen of the sketches made for *The Golfers* and three for *The Grand Curling Match at Linlithgow* are now in the possession of the R&A [15]. These are head and shoulder sketches as compared to two other sketches in the Scottish National Portrait Gallery of Allan Robertson [16] and Sandy Pirie, which are full figure drawings. Whether the sketches are head and shoulders or full length, they match the detail in the final painting.

The next stage was to create a large preliminary work [17], now owned by Jaime Ortiz-Patino and displayed at the Valderrama Golf Club in Spain.

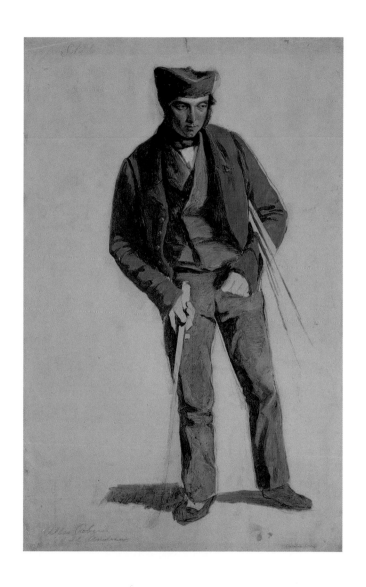

35

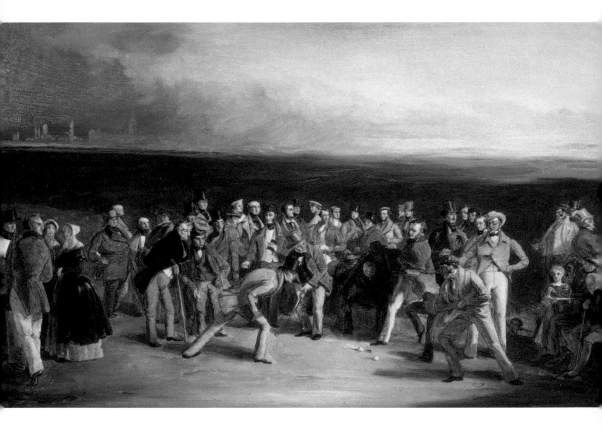

[17] Finished oil sketch of *The Golfers*

Reproduced by kind permission of Jaime Ortiz-Patino

FOLLOWING PAGES

[18] *The Golfers*: detail of the two ball foursome match

On the left are Baird and Playfair and on the right are Paton, the referee in black, and Anstruther. (The fourth player Campbell is shown in the detail on page 51.)

This is much more substantial than either of the two earlier sketches, measuring nearly sixteen inches by twenty-five inches. It contains forty-one people who all appear in the final painting. It is less crowded and lacks the background detail of the finished work. Because there are fewer figures than in the final painting, some are shown in more detail, notably, Colonel William Playfair and James Hay of Leith.

The Golfers: A Grand Match Played over the Links of St Andrews on the Day of the Annual Meeting of the Royal and Ancient Golf Club, to give the painting its full title, portrays a two ball foursome match in which Sir David Baird and Sir Ralph Anstruther take on Major Hugh Lyon Playfair and John Campbell of Glensaddell [18 & 23]. There is no record of such a match in the very incomplete betting books of The Royal and Ancient Golf Club in the 1840s, but there is no reason to suppose that the match did not take place. With the exception of Anstruther all were top class players of the era. One can only assume that Playfair and Campbell must have given strokes to the other team to make the match more even.

Sir David Baird was captain of the R&A in 1843. He won the royal medal twice, in 1841 and in 1850, and the gold medal in 1849. Baird had been one of the founder members of North Berwick Golf Club in 1832, and won that club's Glensaddell gold medal five times during the 1840s – winning it outright with his third consecutive victory in 1849. He died as a result of being kicked by his horse whilst out hunting. Carnegie had written of him in 1842:

> *Sir David Baird can play*
> *With any golfer of the present day.*

His partner in the match, Sir Ralph Anstruther, had served as captain of the club in 1825, while still only twenty-one years old. He was a captain in the Grenadier Guards before standing for Parliament in 1832. Sir Ralph was

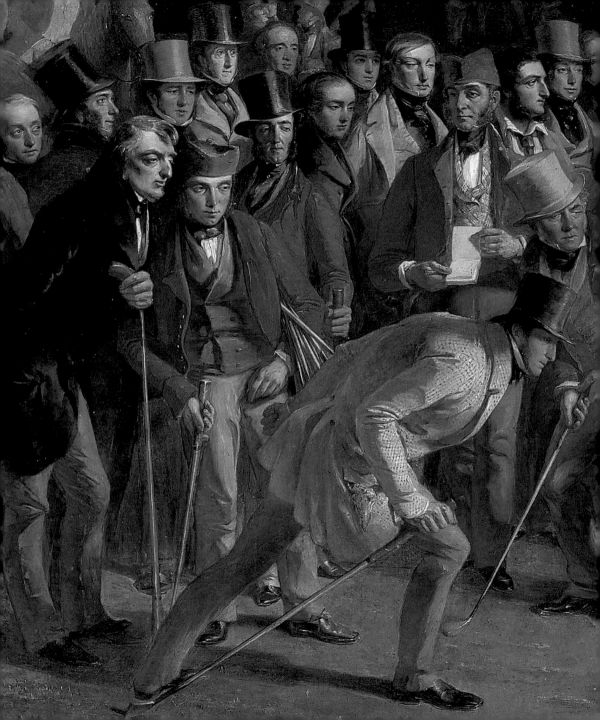

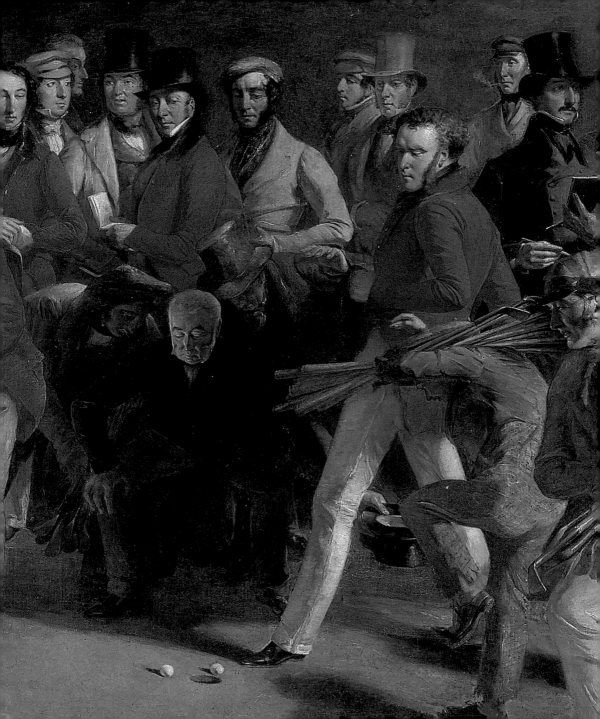

convenor of the Commissioners of Supply from 1853 until 1860, a position that involved responsibility for public health, roads, police and prisons. Carnegie was concerned about Anstruther's putting touch when he wrote in 1833:

> *There's one thing only, when he's on a roll,*
> *He must not lose his nerve, as when he's near the hole.*

A champion golfer in his younger days, Hugh Lyon Playfair went on to make his mark in public life as Provost of St Andrews. He was the driving force behind the creation of the Union Club in 1835 as a facility for golfers, and then in the building of the R&A clubhouse, which was completed in 1854. He did much to improve the area around the Links as well as revitalising and modernising the town of St Andrews. All this came after an active military career in India. When home on leave, he won the R&A and Scotscraig gold medals in 1818. He also won the R&A's royal medal in 1840 and the gold medal again in 1842, as well as the Scotscraig gold medal twice more, and the North Berwick Golf Club's Glensaddell gold medal in 1835 and 1841. He was captain of the R&A in 1856. Carnegie captured Playfair's steely determination in 1833:

> *That Major P——ir, man of nerve unshaken*
> *He knows a thing or two, or I'm mistaken;*
> *And when he's press'd, can play a tearing game,*
> *He works for certainty and not for fame!*
> *There's none — I'll back the assertion with a wager-*
> *Can play the heavy iron like the Major.*

Playfair's partner, John Campbell, was another founder member of the North Berwick Golf Club, which he captained in 1833. He twice won the

Bombay medal at the R&A, in 1849 and 1852. Of him, Carnegie wrote in 1833:

> S——ll dress'd in blue coat plain,
> With lots of Gourlay's* free from spot or stain;
> He whirls his club to catch the proper swing,
> And freely bets round all the scarlet ring;
> And swears by Ammon, he'll engage to drive
> As long a ball as any man alive!

In the painting, Campbell is seen wearing his blue jacket, which, according to Carnegie in 1842, 'now is turn'd to grey'. The match referee was Thomas Paton, seen staring intently at the progress of Playfair's putt. The qualities of Paton as referee fit perfectly Carnegie's description of him five years earlier:

> Short, stout, grey headed, but of sterling worth…
> Good humour'd when behind as when ahead
> And drinks likes blazes till he goes to bed.

A graphic description of the painting, telling the story of the match, accompanied the press advertisements for the print that Alexander Hill published of *The Golfers*:

> The scene is laid at St Andrews, where, during the week, when the
> great Annual Meeting is held, numbers of gentlemen from all
> parts of the country assemble to enjoy his [sic] favourite pastime.
> The numerous portraits introduced into the picture are all
> of gentlemen distinguished as skilful players or lovers of the

* The Gourlay family made feather golf balls.

*game, and have been painted from actual sittings, given to the
artist expressly for this work, every facility having been afforded
him of rendering them faithful and correct likenesses, and
embodying on his canvas, in all its life and spirit, one of the most
ancient, healthy, and exciting of our national games...The ball
nearest the hole has been played by Sir David Baird, with the
cleek, out of the long grass and heather on the left of the picture.
The stroke, always a difficult one in such circumstances, has been
dextrously and well played. The ball has run over the top of the
hole, and lain close at the side. The other ball is supposed to be in
the act of running straight for the hole, the putt having just been
made by Major Playfair. The gaining of this hole being an object
of interest at this crisis of the match, is the point of time chosen by
the artist as the subject of the picture.*

Lees chose the perfect moment for the story his picture tells – a crisis
point in the match, as stated in the advertisement. He conveys the intensity
of the moment by introducing elements of narrative and incident into the
painting. His subjects breathe life into the scene through their actions and
gestures, and their interactions with one another. In this way, we are able to
learn something of the character of many of the individuals portrayed. All
of this heightens the drama of the painting and helps to unify the scene,
something that must have been very difficult to achieve when working with
so many portraits.

On the extreme left of the painting stands Onesipherous Tyndall Bruce
of Falkland, in elegant pose, grouped with two other gentleman friends and

[19] Onesipherous Tyndall Bruce of Falkland

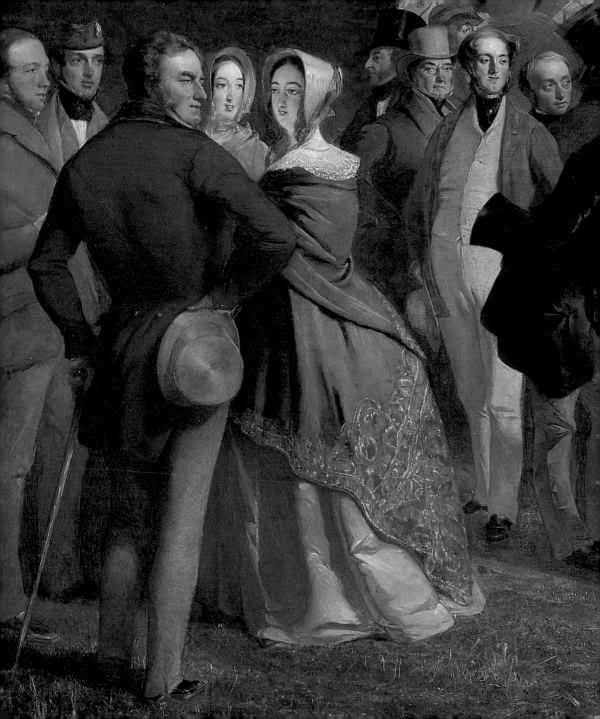

two ladies, one of whom is likely to be his wife, Margaret Bruce [19]. Bruce was in fact a Tyndall from Bristol, but he took his wife's name on their marriage in 1828. Margaret was a wealthy heiress, thought to have been worth £300,000 after the death of her uncle. Bruce was the first Englishman to serve as captain of the R&A, which he did in 1838. He had been a member since 1831. Judging by his expression and pose he looks as though he has just broken off his dialogue with the lady on his right, to turn around and view the progress of the putt. Suddenly he is engrossed in something else. The lady looks at him, as if he is still speaking, or else waiting for him to finish what he had been saying. On the opposite side of the painting, is the oldest gentleman present, George Cheape [20]. He represents a previous generation of golfers, his age dictating that he observe the drama from a seated position. Resting his weight on his stick, his eyes are focused on the two balls in the foreground. Cheape captained the club twice, first in 1801 and then in 1814. He had been a member since 1788.

Behind, and to the left of, Baird and Playfair stands the Earl of Leven and Melville beside a young Allan Robertson [21]. They lean in towards each other, perhaps conjecturing as to which way the match will go, while keeping their eyes fixed firmly on the game. Slightly to the left and just behind the Earl of Leven and Melville stands the Earl of Eglinton in a green tartan coat, tall and erect, with a look of confident indifference on his face – as if he had covered his bets both ways. The presence of Eglinton in the picture has a special interest. The earl, who was instrumental in the creation of the Open Championship in 1860, was not a member of the R&A when the picture was painted. It was not until July 1851 that he was elected – to be followed by being chosen as captain two years later.

[20] George Cheape

44

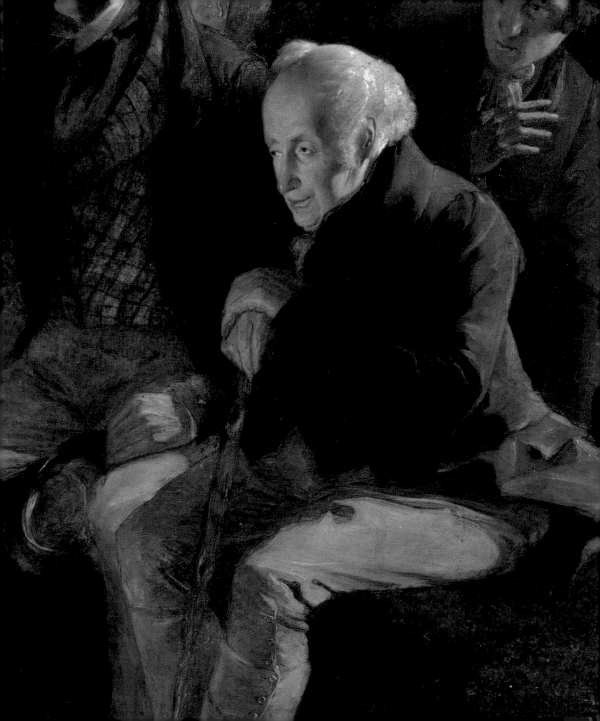

Just behind Allan Robertson's left elbow is John Whyte Melville, a significant force in the fortunes of the R&A. He captained the club in 1823, having become a member in 1816 at the age of nineteen. He was invited to take up the captaincy again in 1883, but he died before he could take office. It was John Whyte Melville who, on 13 July 1853, had the privilege of laying the foundation stone of the clubhouse. His portrait, painted by Sir Francis Grant, hangs in the big room of the R&A clubhouse. Whyte Melville was known, not for his golfing ability, but for his enthusiasm and total dedication to the game. Carnegie aptly described him in 1833:

> *Mount-Melville still erect as ever stands,*
> *And plies his club with energetic hands,*
> *Plays short and steady, often a winner –*
> *A better Captain never graced a dinner.*

Whyte Melville's eyes are fixed on the action. What we cannot tell is whether he is urging the ball to go into the hole or not. Moving towards the centre of the picture, the sense of expectancy heightens, those standing in prime positions with their betting books to the fore. Directly behind Playfair and Baird, and holding his bet book in both hands, is John Grant of Kilgraston [22], brother of Sir Francis Grant, a gentleman whose golfing ability, or lack of it, was eloquently described by Carnegie in 1842:

> *But for John Grant, a clever fellow too,*
> *I really fear that golf will never do!*
> *'Tis strange, indeed, for he can paint and ride,*
> *And hunt the hounds, and many a thing beside;*

[21] The Earl of Eglinton, the Earl of Leven and Melville and Allan Robertson with John Whyte Melville on the far right

46

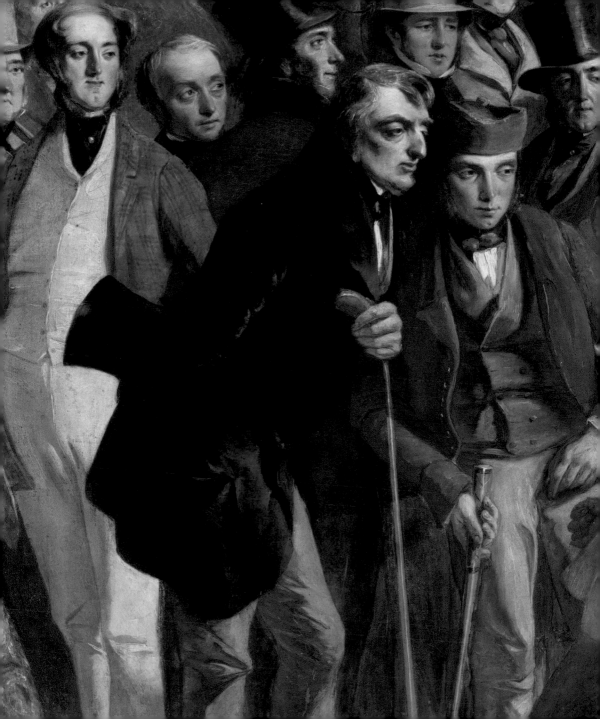

Amuse his friends with anecdote and fun;
But when he takes his club in hand — he's done!

Although John Grant lacked skill, he more than made up for this with his enthusiasm for the game; he had been elected captain of the R&A in 1839. It may be that betting brought him more success than playing. Also standing with their betting books ready to hand are Colonel John Murray Belshes and Sir Norman Lockhart. This aspect of the picture is particularly interesting, for it both testifies to the seriousness with which the match was being taken, and confirms that betting was very much common practice at this time. Belshes peers over the stooping figure of Thomas Paton, the referee, his wager slip clearly visible [see pages 38 & 39]. Further to the right, Lockhart, dressed in black coat and top hat, stands with his pen and book to the ready. His piercing gaze is focused on the drooping head of Sir John Campbell of Airds who is standing next to him. Campbell's expression is one of concern, perhaps even defeat. Are they perhaps adjusting their bets?

On the far right edge of the picture, four gentlemen are deeply involved in conversation, seemingly led by William Wood of Leith. The other three are George Dempster, William Goddard, also of Leith, and Robert Patullo. In the gap between this group and the principal players, Lees has also included the ginger beer girl [23]. He has painted her in picturesque fashion as a sweet ragamuffin, dressed in flimsy clothing, and with bare feet. She serves refreshment to the Hon. Henry Coventry who sits beside the elderly George Cheape. To her right, crouching on the ground, are two other children. They peer through the legs of the adults, hoping for a better view. Behind, oblivious to the drama, is a party of ladies and gentlemen enjoying a picnic.

[22] John Grant of Kilgraston

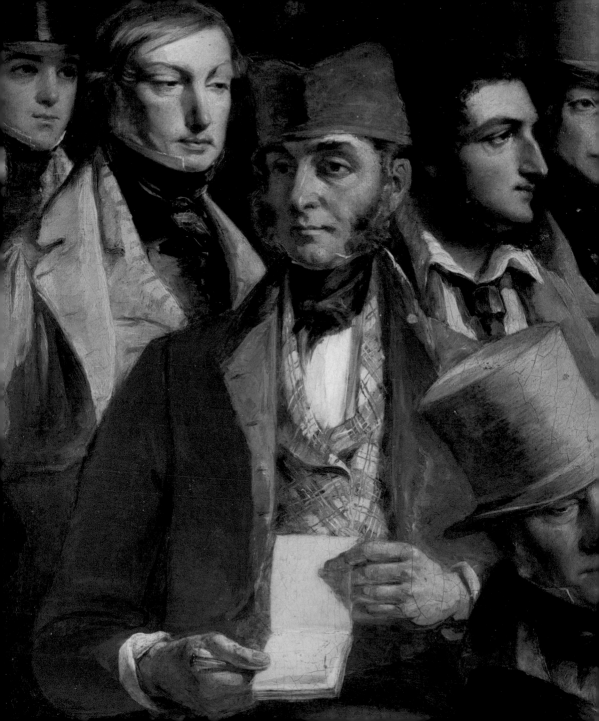

What holds our interest above all, is the uncertainty inherent in the scene. We do not know if Playfair's shot will go past the hole or stop short – or if it is about to go in. To the left, Sir David Baird edges forward to gain a better view, his pose beautifully echoed on the other side by the caddie, Sandy Pirie. Two unidentified figures, one of them gesturing expressively, try to influence the referee, who appears to take no notice.

John Campbell, Playfair's partner, stands back, just behind Pirie, arms akimbo and wonderfully arrogant and aloof. It is a posture that raises the question whether or not his confidence is justified. The left foot of the tense figure of Sir Ralph Anstruther, close by the two balls and hole, also focuses attention on this crucial area. Yet we, who have the best view of all, are still left not knowing what the outcome will be. Lees' success was to capture the essence of this vital moment, to leave it hanging in the air, so that we will wonder forever what happened next.

The painting is a veritable 'who's who' of golf in the 1840s. Thirteen past captains of The Royal and Ancient Golf Club are depicted, along with eleven past medal winners and the future prolific medal winner, James Ogilvy Fairlie of Coodham. The cream of the professionals are also represented by Allan Robertson, the two Piries and Willie Dunn. Looking at *The Golfers* is like taking a step back in time. The painting captures the essence of the game of golf in 1847 and portrays the leading personalities at a time when the game was still almost exclusively Scottish. Above all, it captures that quintessential moment in golf, whether it be in 1847 or the present day. Will Playfair's putt drop into the hole, or not? We will never know the answer to that, but we do know that we are looking at a painting that encapsulates the early days of a great sport.

[23] Sandy Pirie, John Campbell, the ginger beer girl and the Hon. Henry Coventry

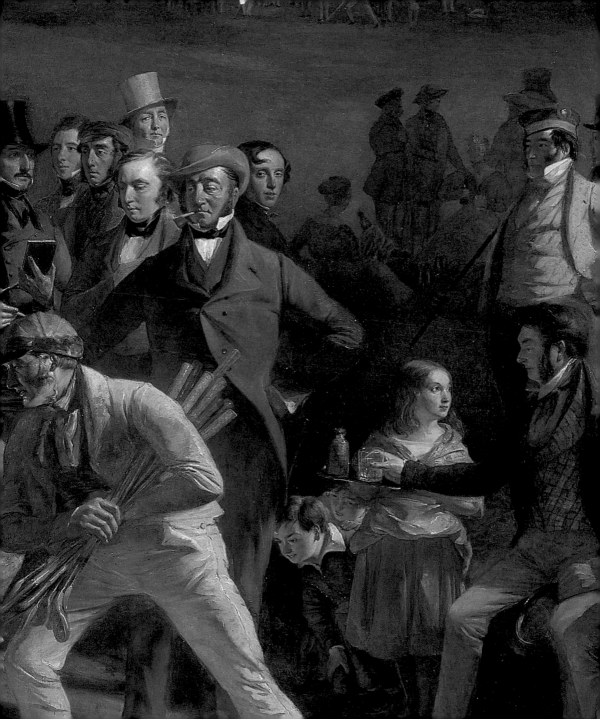

Key to *The Golfers*
by Charles Lees

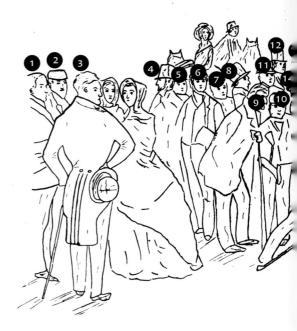

1. Sir John Muir Mackenzie
 of Delvin Bt
2. Sir John Murray Macgregor Bt
3. Onesipherous Tyndall Bruce
4. Sir Charles Shaw
5. Colonel William Playfair
6. The Earl of Eglinton and Wyntoun
7. Robert Lindsay of Straiton
8. James Hay
9. The Earl of Leven and Melville
10. Allan Robertson
11. John T. Gordon, Sheriff of
 Edinburgh
12. John Sligo of Carmylie
13. Hamilton Anstruther
14. John Whyte Melville of Mount
 Melville
15. Lord Berriedale
16. Neil Ferguson Blair of Balthayock
17. The Master of Strathallan
18. John Grant of Kilgraston
19. James Wolfe Murray of Cringletre
20. James O. Fairlie of Coodham
21. John Hay of Morton
22. Sir David Baird of Newbyth Bt
23. Hugh Lyon Playfair

24. Thomas Paton ws
25. Sir Ralph Anstruther Bt
26. John Balfour of Balbirnie
27. The Hon. David Murray
28. John Stirling
29. James Condie
30. Colonel John Murray Belshes of Invermay
31. James H. Dundas ws
32. James Blackwood ws
33. Robert Oliphant

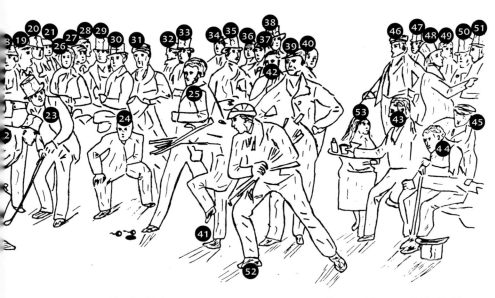